ELLA
Diaries

TOP SECRET!

For Mewanmi, Cristina, Ella and Gwyneth—
total TV stars!— M.C.

Meredith Costain

For Tia, Zadan, Aura, Annette
and Tim— D.M.

Danielle M^cDonald

First American Edition 2021
Kane Miller, A Division of EDC Publishing

Text copyright © Meredith Costain, 2018
Illustrations copyright © Danielle McDonald, 2018

First published by Scholastic Australia, an imprint of Scholastic Australia Pty Limited.
This edition published under license from Scholastic Australia Pty Limited.

For information contact:
Kane Miller, A Division of EDC Publishing
5402 S. 122nd E. Ave, Tulsa, OK 74146
www.kanemiller.com
www.myubam.com

Library of Congress Control Number: 2020949881

Printed and bound in the United States of America

1 2 3 4 5 6 7 8 9 10

ISBN: 978-1-68464-303-5

Diaries

Kane Miller
A DIVISION OF EDC PUBLISHING

Tuesday, after school

Dear Diary,

Guess what?

The most aMAZing
thing happened today!
Ms. Weiss told us our
school is going to be on a TV show!!

Not just any old TV show. The most
incredible, wonderful, spectacular TV show in
the history of TV shows.

It's called QUIZ--ZAM!

Quiz-zam! has a "host with the most," called Harry "The Quiz KING" King.

He has

Sparkly WHITE Teeth

BLUE eyes

and

SPARKLY Perfect HAIR.

Quiz-zam! also has FABulous prizes!

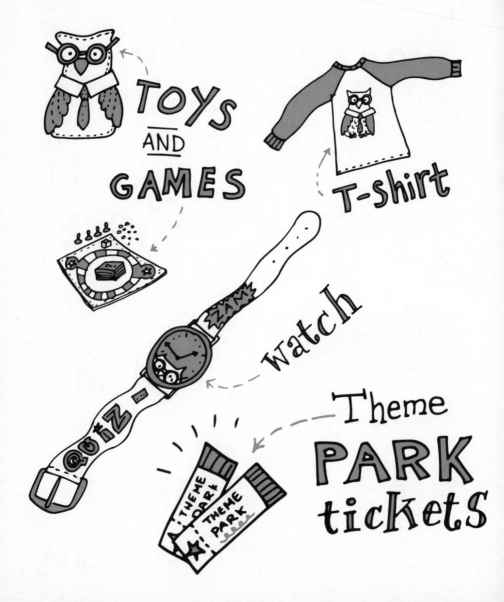

TOYS AND GAMES

T-shirt

watch

Theme PARK tickets

The show even has its own mascot, a sweet little owl called Quizzy. Quizzy helps out by looking up the right answers if there are any problems.

QUIZZY
THE OWL

But the best thing of all is that you get to be on TV. Which means gazillions of people will see you being a TV star. Zow-ee!

ME

LIMO

REASONS WHY I WOULD BE
PERFECT FOR A TV QUIZ SHOW

① I love quiz shows and watch them all the time.

② I have very, very, VERY good reflexes (due to all my ninja training). Which means I would be exTREMEly quick at pressing the buzzer and being the first to answer the questions.

Ninja (ME)

③ I know lots of interesting and unusual facts (especially about animals).✻

✻ Interesting and Unusual Fact No. 1:

Some English people kept a reindeer in their submarine for six whole weeks during a war. And it was called Pollyanna! (The reindeer, not the submarine.)

Reindeer (POLLYANNA)

Submarine

Interesting and Unusual Fact No. 2:

Butterflies can
taste stuff with
their feet.

WARNING: Do not under ANY circumstances
try to taste food with your own feet. Unless
you like food that is completely squished.
(Eww.) And that smells like feet. (Double
eww.)

And guess what? Kids from OUR class will
be chosen to go on the TV quiz show!!!

Ms. Weiss asked us all who'd like to go on it.

And my hand shot
up faster than the
fastest rocket ever
to shoot into space.

Zoe (my best BFF)
put her hand up too. And so
did Amethyst. And Chloe
and Georgia and Poppy. And
Peach and Prinny and Jade.
(Surprise, surprise.) And
some of the boys, like
Peter and Raf and George.

Even Cordelia put up her hand! Which is exTREMEly brave of her. Cordelia has the most GINORMOUS BRAIN of anybody I know, and HEAPS of interesting facts live inside it. But she is also very, very, VERY shy. Even THINKING about going on a TV quiz show would probably make her want to throw up.

CLEVER CORDELIA

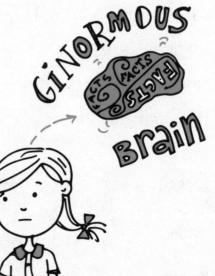

GINORMOUS Brain

FACTS FACTS FACTS

Ms. Weiss gave Cordelia one of her special smiles, to show her that she thought she was being extremely brave too. Then she said it was Wonderfully Heartwarming that so many people wanted to be on the Quiz-zam! team for our school.

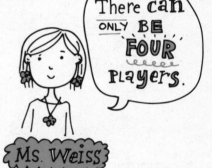

~~unforch~~ Unfortunately, she also said there can only be FOUR players.

There can ONLY BE FOUR players.

Ms. Weiss

There are twenty-six students in our class. And FIFTEEN of them are ~~desperately desperate~~ to be on the show.

Which means . . .

Tryouts.

So all the people who want to be on the show are going to do a practice quiz game tomorrow in class to see who will make the best players.

I hope one of them is me! And also Zoe. We ~~always~~ mostly do EVERYTHING together.
☺☺☺

Have to stop writing now, Diary.
I need to go to the library to
borrow some big books of facts
so I can get ready for tomorrow.

Yours 4 ever,
Ella
xxx

Tuesday night, in bed

Dearest Diary,

I have been reading interesting and unusual
facts for HOURS!

My brain is so full of facts and figures and weights and speeds and ages and names it is going to BURST!

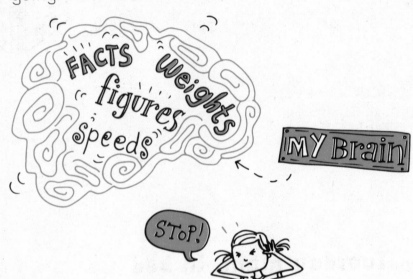

No one in my family wants to speak to me anymore, in case I tell them how big the biggest man that ever lived was,

or how many
birthdays Galapagos
tortoises have,

or which famous queen's undies got sold in
an auction. (Eww. That is just *weird*. I hope
nobody ever tries to sell my undies, even
if I'm the most famous
person in the history
of famous people by
then. Or a queen.)

So I told all this to
Bob instead.

BOB

I hope some of these facts come up in the quiz tryouts tomorrow!

Good night, Diary.
Sleep tight.
E
xOxO

Wednesday, after school

Dear Diary,

We had the tryouts today. All the kids who wanted to be on the show had to line up at the front of the class.

And guess who pushed her way to the very front of the front of the line?

You got it. Precious Princess Peach Parker, the pushiest, peskiest person in the history of pushy, pesky ~~persons~~ people. And pushing in right next to her were her pesky BFFs, Prinny and Jade. Peach kept looking around with a superior, sneery smirk on her face, to show how much more intelligent she was than everyone else.

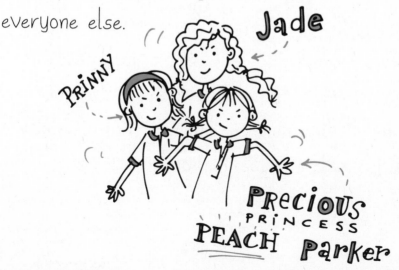

Jade

Prinny

PRECIOUS
PRINCESS
PEACH Parker

Then Ms. Weiss
asked each person
a question, like the
ones they have on TV
quiz shows. And if
you got your question wrong,
you had to sit down again.

Questions

The first questions were super easy, like
how many legs does a spider have. Or how
many weeks are there in a year. But then
they got trickier and trickier and harder
and harder. After three rounds, everyone
was sitting down except for Peach, Peter,
Raf, Amethyst, Zoe, me, and Cordelia.

Peter and Amethyst went out in the next round. So there were only five players left,

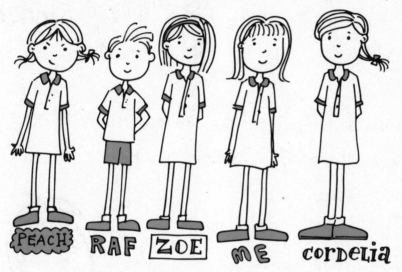

PEACH RAF ZOE ME cordelia

which meant the next player to give the wrong answer would be

O - U - T

spells OUT

of the team.

Zoe and I gave each
other a special secret
thumbs-up signal for
good luck.

Then Ms. Weiss told us the questions in
the next round were going to be all
about space.

YES! I read heaps of
facts about space in
*My Biggest Best Book
of Space* last night, so I
was feeling superconfident!

Here's what Ms. Weiss asked Peach:

Q: How many planets in our solar system have rings?

"That's easy peasy," Peach said, smirking. "Everyone thinks only Saturn has rings because they're easy to see. But Jupiter, Uranus, and Neptune have them too. So the answer is four. FOUR planets have rings."

FOUR

ZOW-ee!

How did Peach know that? She must have been reading *My Biggest Best Book of Space* too. ☹

Ms. Weiss said, "Correct!" and everyone clapped and cheered. Especially Prinny and Jade. And Peach tossed her head and gave everyone one of her shark-tooth smiles.

BLEUChhh.

Then it was Raf's turn. This is what Ms. Weiss asked him:

Q: Which space object do many people believe caused dinosaurs to become extinct?

It's SOOO not fair that Raf got that question! Raf's mom works at the museum in

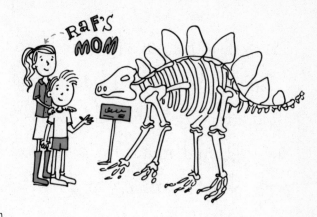

RAF'S MOM

the part where all the dinosaur bones live. He knows EVERYTHING about dinosaurs, including all their long dinosaur names and how many toes and teeth they had and what they ate for breakfast.*

* Other dinosaurs, mainly. Unless they were the vegetarian type that only ate vegetarian stuff like grass and leaves and broccoli. (Broccoli. Bleuchhh.)

I shut my eyes tight and crossed my fingers behind my back. Maybe Raf would forget that this was the space round. And make up a reason that had absolutely *nothing* to do with space.

Like how they all went out for a nice walk one day and fell into the bottom of an erupting volcano and couldn't get out again.

Dinosaurs

VoLcano

Or how they all got eaten by a gigantic dinosaur who was the great-great-great-great-grandfather of Godzilla.

Gigantic
DINOSAUR

And then Raf would be out and Zoe and I would both be on the team 100% for sure.

But guess what?

He didn't.

He said the object from space was a gigantic asteroid. Which was the right answer.

GiGANTiC ASTEROiD

So Raf was safe. ☹

Then it was Zoe's turn.

Q: What is the HOTTEST planet in our solar system?

Zoe's forehead went all crinkly, which meant she was doing DEEP THINKING about the answer. And then she looked up with shiny eyes and said, "Mercury! Mercury is the closest planet to the sun, which means it must get SUPERhot!"

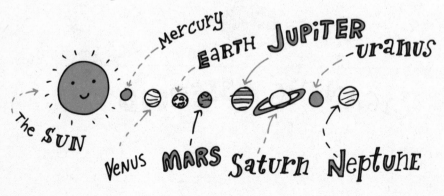

Noooooooooool!!

Zoe's answer was **WRONG, WRONG, WRONG.**

The hottest planet is ~~acksh~~ actually Venus!
I read all about it last night, just after Olivia
promised not to EVER use any of my glitter
pens again if I'd stop telling her interesting
and unusual facts about Rivers and Lakes of
the World. Or Famous Buildings. Or Olympic
Records Through the Ages. (I didn't.)

Ms. Weiss gave her a sad little
smile. And then she spoke the
Words of Doom.

"I'm sorry, Zoe, but that answer is incorrect."

Then Ms. Weiss asked me and Cordelia a tricky space question each, to finish the round. Cordelia's question was even trickier than mine! But we both got them right.

Q: Who was the first dog in space?

★The first DOG in SPACE was a STRAY DOG from RUSSIA CALLED LAIKA!

Q: How many planet Earths could fit inside the sun?

ONE MILLION. OUR SUN is enormous!

So we're both safely on the team. **Phew.**

Except that also means that Zoe isn't. ☹

Zoe shuffled sadly back to her seat, her heart shattering into gazillions of tiny pieces. Just like the glass in your family room window does when you're playing in the backyard with your brother and sister and best friend and a soccer ball, and you accidentally knock the soccer ball into it. (**Ooops.**)

So anyway, here is our official team for the TV quiz show.

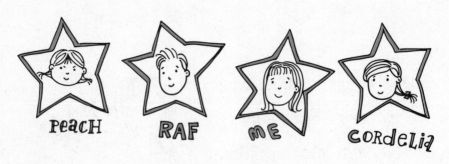

PeacH RAF ME CORDeLia

which is extremely exciting! But also sad.

How am I supposed to enjoy being a TV ~~selleb~~ ~~cellerb~~ ~~celleb~~ star without my BFF being one too?

Yours in deep sorrow,
Ella

Wednesday night, in bed

Dear Diary,

I told everyone in my family I was going to be on TV. And they all gave me a big hug and said,

and other nice things like that.

Even Olivia gave me a hug. which is really weird, Diary, because Olivia NEVER does stuff like that.

WHAT OLIVIA USUALLY DOES WHEN I TELL MY FAMILY GOOD NEWS ABOUT IMPORTANT AND EXCITING THINGS I HAVE BEEN DOING

Guess **what?** **I WON** Second **PRIZE** for MY decorated cupcakes **IN the COOKING** contest.

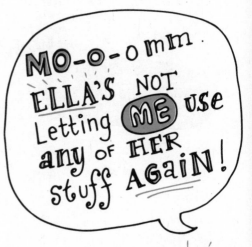

MO-o-o mm. ELLA'S NOT Letting ME use any of HER stuff **AGAIN!**

And guess what? Dad cooked me a special dinner to ~~cellarbrate~~ celebrate!

He said I could choose ALL my favorite things to eat.

Here's what I chose:

PiGS in Blankets*

* Pigs in blankets are sweet little cocktail sausages wrapped up in pastry. They are NOT real pigs in real blankets. That would just be weird.

Spaghetti
BOLOGNESE

Banana Split

LiME Spider **

fizzing BUBBLES

Vanilla
ICE CREAM

LiME CORDiaL
Lemonade

** A lime spider doesn't have a real spider in it either. It is a fizzy drink.

❄ 36 ❄

Nanna Kate came over to say congratulations too. And then after dinner we all played this really excellent board game called "Smarty-Pants" that Zoe and I made up once when it rained all day and we were BORED, BORED, BORED because there was nothing else to do.

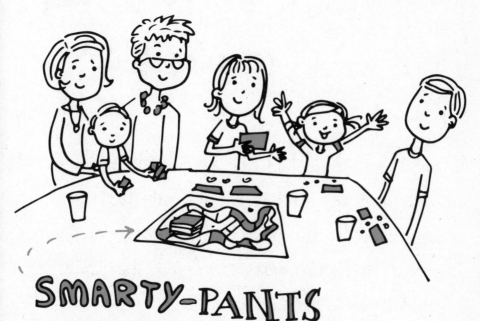

SMARTY-PANTS
~~bored~~ board GAME

And guess who won?

HINT: Her name (almost) rhymes with the name of that sweet girl who wanted to go to the ball but couldn't and ended up living happily ever after.

(Cinder) ELLA

☺☺☺☺

And then Olivia had one of her little tantrums and said it wasn't fair that I got to do all the good stuff like go on TV shows. And when was it going to be HER turn to be a shining star?

And then she sat down in the middle of the
room with her lip turned
inside out. She looked
exACTLY like a cross
little piglet.

So I went over and gave her a gigantic hug.

And so did Max. Only from the other side.

And then Bob sat on top of us.

And we all fell over.

Adiós, amigo.✳✳✳

E

X

✳✳✳ "Adiós, amigo" is what people living in Mexico say to their friends instead of "goodbye." I learned that last night in my Countries Around the world book.

Wednesday night, very, very late (still in bed)

Dearest Diary,

I have been lying here for HOURS, tossing and turning like a hamburger patty being flipped over and over in a hot hamburger shop, worrying about Zoe.

Zoe is really sad she missed out on being an official member of the team.
It is BREAKING HER HEART!

It's so not fair. I bet if that last question Ms. Weiss asked her had been about horses instead of hot planets she would have known the answer for sure.

* Zoe is horse mad and knows EVERYTHING about them.

Ooooooooo. I've just had one of my brilliant ideas!

BRILLiaNT iDEA!

ZOE

Zoe can be our TEAM EMERGENCY PLAYER! All teams need an emergency player. I am going to write a petition about it and give it to Ms. Weiss tomorrow!

E

Wednesday night, about fifteen minutes later

Here is what I wrote in my petition:

Dear Ms. Weiss,

I am writing to ~~perswade~~ ~~perswaid~~ persuade you that our team for the TV quiz show needs an emergency player.

(And also to let you know that Zoe would make an exceptionally good one if you agree with me.)

HERE ARE THE REASONS WHY WE SHOULD HAVE AN EMERGENCY PLAYER

1 Maybe one of our official team players might have a missing cat. And they might be standing

on a tall ladder looking over a high fence to see if their cat is on the other side. And then they might fall off and smash their elbow and head and knee parts into smithereens. And then all their guts would come out. Which would make it extremely hard for them to go on a TV show.

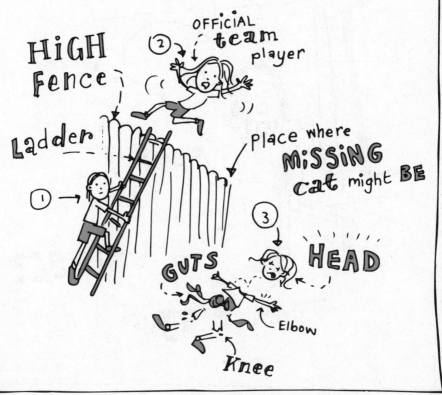

② Or maybe that player has to walk around all the nearby streets for HOURS, calling out for their missing cat, and their voice disappears completely, like this . . . POOF!! So they can't answer questions anymore.

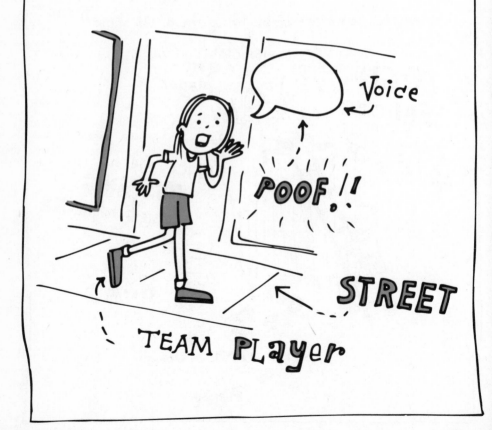

③ Or maybe they ~~acksh~~ actually DO find their missing cat, but it's been hanging out with another cat with a horrendously horrible disease, and now their (the official team player's) eyes are all gummed up and they have an itchy red rash all over their tummy and no one wants to sit next to them on the panel in case they catch the horrendously horrible disease too.

① TEAM PLAYERS (example ONLY)

BEFORE
finding the MISSING CAT

②.TEAM PLAYERS **AFTER** finding t**h**e MISSING **CAT**

④ ~~Zoe and I have been best friends forever and~~ ~~ever and do everything together and we would~~ ~~DIE if we don't both get to be on the TV show.~~*

Thank you for considering my request.

Yours truly, faithfully, and sincerely,

Ella

* I decided to cross the last part out in case it wasn't "petition-ish" enough.

YESSSSSS! This is perfectly perfect!

Talk more tomorrow!
E xx

Thursday, after school

Dear Diary,

I gave Ms. Weiss my petition as soon as I got to school. And she read it right in front of me, very seriously. And guess what she said?

And guess what else she said? One of the other schools going on the show dropped out. And now we are going to be on the TV quiz show next week, starting on Monday! And we will be going there for four days to do all the filming.

So Peach and Raf and Cordelia and I quickly had an official team meeting in our classroom at lunchtime.

Zoe came along too. Here is a special sign she made for the door:

KEEP OUT!

Official TV QUIZ SHOW

TEAM Meeting in PROGRESS.

only OFFICIAL QUIZ Team (AND EMERGENCY) MEMBERS ALLOWED

WARNING THIS MEANS YOU!!

51

Zoe and I kept checking the door in case any little kids tried to break in so they could meet us, now that we were going to be big, important TV stars.

But nobody did. ☹

The first thing we had to do was choose an exciting name for our team.

Here are some names that we came up with. And also the ratings that Zoe and I gave them.✳

✳ Secretly, after the meeting was over.

QUIZ TEAM NAMES AND OUR (SECRET) RATINGS FOR THEM

Team Name	Who Said It	Star Rating Out Of 5	Reason For Rating
Peach's Pets	Peach	0	(Yawn)
Noodle Squad	Raf	★	Too weird
The Bright Sparks	Zoe	★ ★ ★	V. good
The Mind Bogglers	Me	★ ★ ★	Also v. good
The Quizzly Bears	Cordelia	★ ★ ★ ★ ★	AMAZING!!!

Everyone voted for Cordelia's
name, The Quizzly Bears.
It is PERFECT for our
team! Even Precious Peach
liked it, and she NEVER

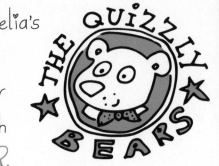

usually likes anything she hasn't thought up
herself.

We all gave Cordelia a big clap and told her
how clever she was. (Which made her
face go all pink and shiny, like
a shiny pink face.)

Then Peach handed around some
pieces of paper with drawings on
them that she did when we were

supposed to be working on our Famous
Explorers of the World projects this morning.
And guess what the drawings were of?

If you guessed Christopher Columbus
sailing the ocean blue or Marco Polo playing
polo or Sir Edmund Hillary meeting the
Abominable Snowman
you are WRONG,
WRONG, WRONG.

Sir EDMUND Hillary

Abominable Snowman

The drawings were of
our team outfits. For the TV show. (Which is
really unfair because Peach knows that I'm
the one on the team with the special design
skills. Designing stuff is MY LIFE.)

This is what they looked like:

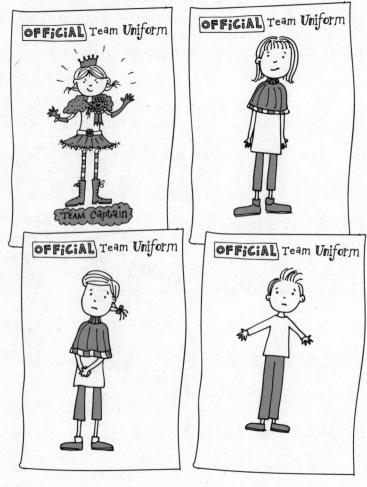

And this is what we all said next:

Me (to Peach, suspiciously): How come your outfit is the best? And the most designer-ish?

Raf (also to Peach, even more suspiciously): And how come you have a team captain badge?

Peach (smirking): Because I got picked for the team first.

Raf: No, you didn't.

Peach: Yes, I did.

Raf: Didn't.

Peach: Did. I was the first person to get the right answer in the deciding round.

Raf: That's because you were standing at the front of the line. That doesn't mean anything.

Zoe: Exactly.

Peach (to Zoe, huffily):
who asked you? You're
not even an official team
member.

Zoe (hurt): ☹

Me (loyally): Yes, she is. Ms. Weiss said she
can be our OFFICIAL emergency player.

Peach (rolling her eyes): Hmmph. Well,
anyway, Ms. Weiss ALSO said I could be
team captain.

Raf: Bet she didn't.

Peach: Did.

And then Cordelia (bravely)
pointed out that none of the

other teams on the show even had a
captain. And they all just wore their school
uniforms.

So that's what we're going to do too. (I don't
think Peach is very happy about it though.
ESPECially the team captain part. Hehehe.)

Have to go now, Diary. I have to go and
learn some MORE FACTS!

Cheers,
Ella
X

Friday, after dinner

Dear Diary,

Zoe and Cordelia came over after school so we could watch some old episodes of Quiz-zam!

There are four different rounds and you have to do different things in each one. And the players from each team that get

the lowest scores in the first two rounds get dropped from the team. (Eek. I hope that's not me!)

Here are all the different rounds:

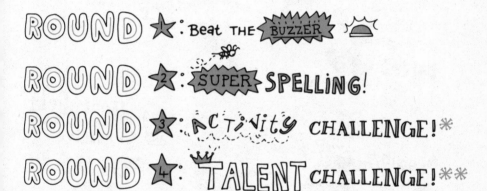

ROUND ★: Beat THE BUZZER

ROUND ★2: SUPER SPELLING!

ROUND ★3: ACTivity CHALLENGE! *

ROUND ★4: TALENT CHALLENGE! **

* You get to do really fun stuff in this round, like races with buckets of water on your head. Or building forts or mythical animals out of cardboard boxes.

✳✳ The talent challenge is PERFECT for me, as I have so many different talents!

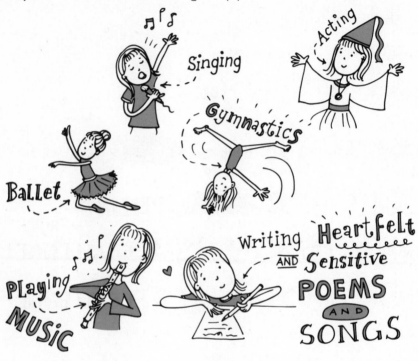

And the GRAND WINNER is the team that gets the biggest total number of points at the end of the four rounds.

And then you get really fabulous prizes, like
something for your school, ‚ ‚ ‚ ---Theme
or theme park tickets PARK
for your whole family! tickets

Zoe and Cordelia are going to come over
again tomorrow night for a sleepover. And
we are going to practice all the different
rounds so we can be ready for next week.

It is going to be EXcellent. And aMAZing.
And fantastically FABulous!

I can't wait to get started!!!

E

Sunday morning, after breakfast

Good morning, Diary.

We had our sleepover. And it was excellent!
(Especially as Olivia wasn't there to annoy
us. This is because she was having her OWN
sleepover at her BFF Matilda's place.*
YESSSS!)

* After I begged Mom to ask Matilda's
mom to ask Olivia if she wanted to come
over to play with Matilda. I was ~~acksh~~
actually hoping she might stay at Matilda's
place ALL WEEK, but Mom said no. (And
so would have Matilda's mom, after Olivia

accidentally ruined
some of their best
saucepans doing
scientific experiments
in them with Matilda
last time she stayed over.)

Scientific
EXPERiMENTS

We played Cassi Valentine music and
gave each other ~~profeshunal~~ professional
makeovers—just like real TV stars have!

ME!

zoe!

←--CORDeLia !!

I used my special designer-ish skills to casually throw together some stylish outfits. (For when we all get invited to the annual Sparklies TV Awards for being excellent on a TV quiz show.)

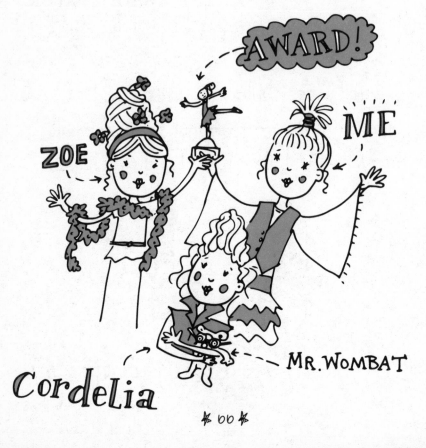

And then I borrowed Dad's ancient video camera and we videoed each other, like we were really truly ~~acksh~~ actually on the show.

Cordelia thought it would be a good idea to practice buzzing the buzzer for the **Beat THE BUZZER** part. We didn't have any REAL buzzers, so we used some of Bob's squeaky toys instead.

~~Unforch~~ Unfortunately, Bob thought we were playing a game, and kept trying to retrieve them.

SQUEEEKKKA!

SQUEEEKKA!

Then we turned the music UP UP UP and tried out some crazy dance moves for the 👑TALENT CHALLENGE! Mine were THE CRAZIEST. ☺

Then Mom came in and said we had to turn the music off because Max was trying to sleep. And so were all the rest of our neighbors. (Especially Mr. Supramaniam who lives next door and has a weak heart.) So I decided to do something nice and calming instead. Like writing this song about our fabulous quiz show team.

Quizzly Bears are fabulous
Quizzly Bears are ace
We're grizzly and we're drizzly and
We come from outer space!
We answer all the questions and
We never get them wrong
We're the grizzly frizzly Quizzlies and
We hope you like our song!
Drizzly Bears
Frizzly Bears
On our way to fame!
Grizzly Bears
Quizzly Bears
We always win the game!

And then we sang it very quietly,✳✳ so we didn't hurt poor Mr. Supramaniam's weak heart.

✳✳ Except for the very last part, about the Grizzly Quizzly Bears winning the game because we got all excited and forgot. OOPS!

Talk later, Diary!
Yours 4 EVER,
Ella

Sunday night, in bed, very, very late

I just had the most terrible dream!

In my dream I was riding on a ghost train.
And there were zombies and ghosts with
big googly eyes all around me. And they
kept asking me questions. Lots and lots of
questions, really, really fast. Like this:

How MANY TOES do YOU have?

What's your NAME?

How many Brothers and SiSters do You have?

How many HEADS do You have?

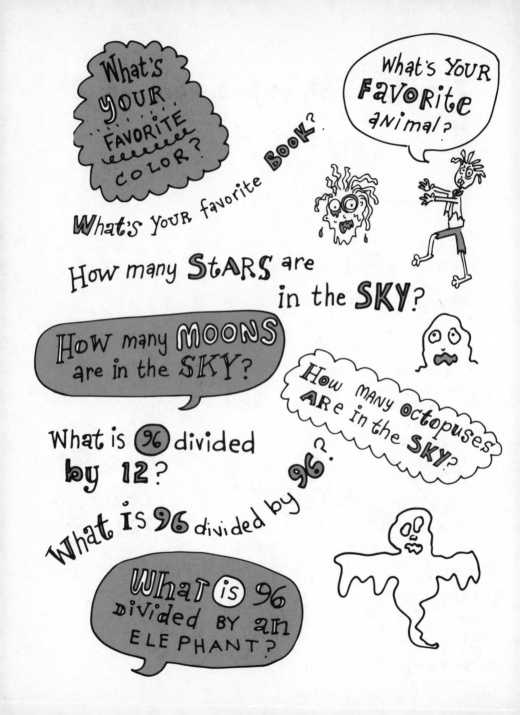

I kept trying to open my mouth to answer the questions, but I couldn't. And all the zombies were pointing at me and laughing. Like this:

HA
"HA ha ha"
Ha
"HA ha"

And then a girl wearing a T-shirt with TC on the front and mangoes on her head climbed onto the train too. And guess what?

mangoes

TC

She answered all the questions. And she GOT THEM ALL RIGHT. (Even the one about how many octopuses there are in the sky.*)

And everyone was clapping and cheering and stamping their feet.

And then I woke up.

What do you think it all means, Diary???

* The answer is 64, in case you were wondering.

Monday, just before bedtime

Dearest Diary,

Today was our first
day on Quiz-zam!

Peach's mom picked us all up from school at
recess in her gigantic car. It was just like
being in our own private limo!

Zoe came too, in case any of the official
team players had to drop out because of
Unforeseen Circumstances (or someone
accidentally stood next to the missing cat
with the horrendously horrible disease).

And guess who made sure she was sitting in the front seat?

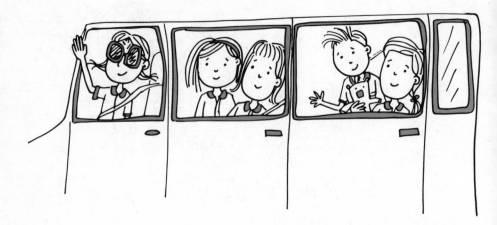

Bleuchhh. Peach is SOOO annoying ~~sometimes~~.

Chloe and Georgia and Poppy made a big good luck sign and waved at us as we went out of the school gate.

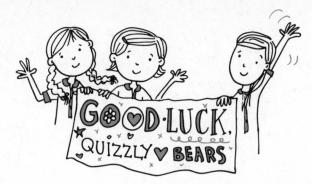

And guess who was standing right next to them?

Prinny and Jade, waving an even BIGGER sign.

Double bleuchhh.

We arrived at the TV studio, which is the big place where they do all the filming of Quiz-zam! The people who will be working on our show are called Sasha and Jake and they are very friendly and nice. And they both have exCEPtionally stylish hairstyles.

Sasha

Jake

They gave us name tags shaped like Quizzy, with our names written on the front in big letters.

Name TAG

ELLA

~~Unforch~~ Unfortunately, they spelled Peach's name wrong on her name tag. So then they had to quickly make her a new one. Oopsies!

And then they told us to wait in a room called the Green Room which had a sweet little table with snacks on it.

We waited.

And waited.

And waited, getting more and more nervous. Even Peach looked nervous.

But nothing happened. I was just about to
reach over and get one of the snacks when . . .

Da Da Da... Dummm.

The door opened and . . .

The Bad News

A whole lot of scary zombies with googly
eyes came in. Just like in my dream.

NOooOooooooooo!

The Good News

Ha ha. Only joking. ☺

The OTHER team for the show came in.
Their name was

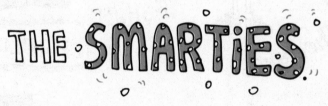

And guess what? They were all wearing
T-shirts in different colors! And the girls
had hair scrunchies that exACTly matched
the color of their T-shirts. And the boys'
shoelaces matched THEIR T-shirts.

RAVI

RED T-SHIRT

RED Shoelaces

BLUE Scrunchie

EXACTLY the same BLUE T-SHIRT

CHARLOTTE

OLLIE

YELLOW Scrunchie AND MATCHING YELLOW T-SHIRT

Green T-SHIRT + Matching Green SHOELACES

JORJA

Zow-ee. They looked aMAZing! Why didn't
WE think of doing something like that? We
could have had matching bear masks. ☹

Sasha and Jake made
name tags for them too.
The Smarties weren't
nervous like us though. Not even a little
bit. They were superconfident. Especially
Jorja, the girl in the yellow T-shirt.

And then they took us all into this big
room with lots of lights and cables and
cameras on wheels and TV show directors
and people running madly around like mad
things with clipboards and microphones.

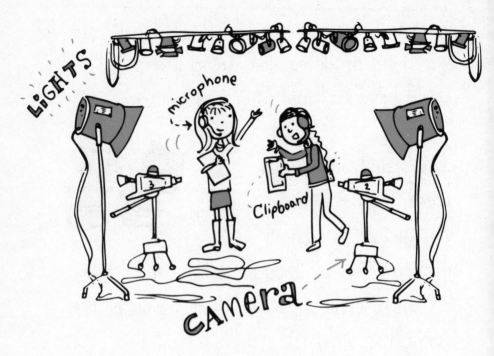

LIGHTS

microphone

Clipboard

CAMERA

And we could see rows and rows of people sitting in those chairs with fold-up seats like they have at the movies, waiting ~~paichently~~ patiently for us to come out and be TV stars.

It was SOOO Exciting!!

Even Cordelia looked excited!

Jake told us to line up behind two shiny counters that had flashing lights and gigantic buzzers on the top. (REAL ones!)

And then Harry "The Quiz King" King bounced into the room with his sparkly eyes and sparkly smile and perfect hair!

HARRY THE QUIZ KING

And the Quiz-zam! theme music played!

And a man held up a big sign saying

APPLAUSE

and all the people sitting in the movie theater seats started clapping and cheering!

And then

Sorry—have to stop writing now, Diary. Mom just came in and told me it was time to turn my light off and GO TO SLEEP.

Nighty night,
E

Monday night, about half an hour later

Dear Diary-doo,

I am WAY too excited to go to sleep.

Every time I close my eyes I keep seeing flashing lights. And colored T-shirts. And Harry The Quiz King's teeth. (Eww.)

flashing Lights

COLORED T-Shirts

HARRY the QUIZ KING'S TEETH (Eww.)

So I am going to write a bit more about what happened today instead.

First of all we did:

ROUND ☆: Beat THE BUZZER

All the players from each team played in the first part.

Harry read out lots of questions and if you knew the answer you had to push your buzzer straightaway. And if you got the answer right you scored points for your team.

The Smarties were super-duper fast at buzzer pushing. Much faster than our team. (Even after all that practice we did with Bob's squeaky toys. ☺)

So they won that section.

And then in the second part, Harry asked us all questions one by one, just like in our tryouts. And guess what? I got all my questions right! Even the really tricky ones, like where do grasshoppers' ears live?

If you said on their head you are
WRONG! WRONG! WRONG!

That's because grasshoppers' ears live on their tummies! They can hear all the other grasshoppers singing little grasshopper songs to them.

ON their TUMMY!

And then after I answered my question about grasshoppers' ears, I told everyone that grasshoppers also have five eyes! And that they often get eaten by praying mantises, which are my second-favorite animal (after dogs). Which means I know EVERYTHING about them.

And then right after I said that a buzzer started buzzing, like this:

and flashing lights started flashing behind our team, like this:

FLASH! FLASH! FLASH!

and the words **BONUS POINTS**

appeared on a gigantic screen.

And then the man standing in front of the audience held up the big **APPLAUSE!** sign again.

And everyone in the audience magically started clapping and cheering.

It was aMAZing! And EXcellent! And fantastically fabulous!

And guess what? It was just as well I DID get those super-duper extra bonus points for knowing interesting and unusual information about grasshoppers and praying mantises. Because Peach got a question wrong. And Raf got two wrong! But The Quizzly Bears still won the round!

YESSSSSSSSSSSSSS!

ROUND ☆: Beat THE BUZZER

The SMARTIES	The QUIZZLY BEARS
	(with **50 BONUS** points)
80	**100**
POINTS	POINTS

The player with the lowest score from each team didn't get to go on to the next round. So it was bye-bye Ollie and Raf.

So now it's just me, Cordelia and Peach left on our team.

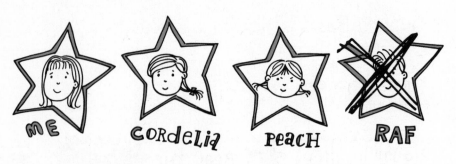

ME CORDELIA PEACH RAF

I can't wait until tomorrow when we have Round Two!

Good night, Diary.
Ella xx

Tuesday, after dinner

Dear Diary,

Peach's mom picked us up from school at recess again to go back to the TV studio for today's filming. But first we had to learn about fractions in class (bleuchhh) and it is really, REALLY hard to concentrate on things like mixed numbers and denominators when your head is full of bwarping buzzers and flashing signs.

Everyone in our class kept bugging us to
tell them what happened on the TV show
yesterday. But we are
strictly STS (Sworn to
Secrecy). Especially Raf.

STS
(Sworn to
Secrecy)

Peach has been swanning around everywhere
like a smirking swan,
offering to sign people's
schoolbags. Or project
folders. Or arms.

So now everyone thinks that SHE was the
star on the TV show yesterday. When it was
~~acksh~~ actually me. ☹

Zoe and I are SHOCKED. And so is Cordelia.

It's SO not fair. I was BURSTING to tell someone about my super-duper bonus points.

I couldn't even tell my family last night (in case blabbermouth Olivia blabbed to Matilda. And then Matilda blabbed to all

her friends. And then THEY kept on blabbing until the WHOLE SCHOOL knew about it).

So I told Bob instead.

Have to go, Diary, Nanna Kate's on the phone! Will write more about what happened today soon.

Love,
Ella
X

PS Peach is not the only one on this show who thinks she is a star. Jorja and Charlotte do too. Yesterday during a break I saw Jorja telling Ollie and Ravi not to talk so loudly because she needed to RELAX between filming sessions. And then Charlotte told Jorja to stop being so loud when she was telling them that because SHE was trying to relax. And then they had a BIG LOUD ARGUMENT about who should be quiet.

Bleuchhh.

Tuesday night, about fifteen minutes later

I'm back!

Today's round was

ROUND ☆2☆: SUPER SPELLERS!

Here are some of the tricky words we had to spell:

PHARAOH

WEIRD ←(this one was **SUPER** EASY for **ME** ☺)

EMBARRASSING ←--(so was **this** one ☺☺)

FEBRUARY

BROCCOLI ← (bleucHhh)

ACCIDENTALLY

CATERPILLAR ← (easy peasy)

MEERKAT ← (even MORE easy peasy)

DUNGEON

GHOUL ← -- (I'm not ~~acksh~~ actually
 100% SURE what this even iS)

And guess what? One of the words was
RHYTHM, which is my most favorite word
to spell in the whole ~~wild~~ wide world.

Nanna Kate taught me a special secret way
to remember it. You do a little dance with
your shoulders as you say the letters, like
this:

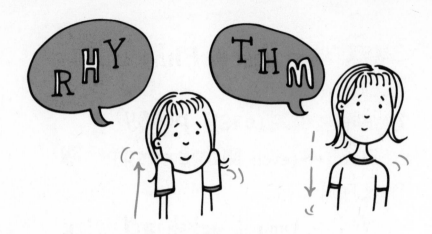

As soon as Harry said the RHYTHM word I
pushed the buzzer. And so did Cordelia and
Peach. But smarty-pants Smartie Charlotte—
the fastest buzzer pusher in the history of
fast-buzzer pushers—got it first.

Charlotte

AAAAARRRRGGGHHHH!

That should have been MY ten points. ☹

The last word in the *SUPER* SPELLERS! round was worth TRIPLE POINTS!!!

And The Quizzly Bears were TWENTY points behind! If we got this one right, we could win the round!

And the word was . . .

wait for it . . .

Here it comes . . .

DIARRHEA.* (Eww.)

* If you don't know what diarrhea means then you will have to look it up yourself. Because if I have to explain it I might go all wibbly wobbly in the tummy part and throw up. (Double eww.)

WIBBLY wobbly TUMMY,, (DoubLe eww.)

THE BAD NEWS

Super-Buzzer-Pusher Charlotte pushed the buzzer first. Again. ☹

THE GOOD NEWS

She got it wrong!!! ☺

THE ~~GOODER~~ BETTER NEWS

The mighty Quizzly Bears now had a chance to win! ☺☺

THE HORRIFYINGLY HORRIBLE NEWS

Nobody on our team knew how to spell it either. ☹☹☹

We all just stood there looking at each other as the timer slowly ticked down.

Then everyone in the audience started jumping up and down like jumping grasshoppers screaming, "Come on, Quizzly Bears!" and "You can do it, Quizzly Bears!"

And then they started counting down the last ten seconds, like this:

And then just as they were about to say
"One . . ."

Brave Cordelia bravely pushed her buzzer!

YESSSS!

THE ~~WORSEREST~~ WORST NEWS YOU COULD EVER IMAGINE IN A ZILLION GAZILLION YEARS

She got it wrong.

And The Quizzly Bears lost the round. All because of stinky pinky diarrhea.

ROUND 2 : SUPER SPELLING!

The SMARTIES

150 POINTS

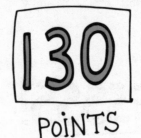

The QUIZZLY BEARS

130 POINTS

Bleuchhh.

That word should just be
BANNED. ForEVER.

Tuesday night, about twenty minutes after that

Oops! I forgot to tell you the most
important thing!

Cordelia got the lowest score for our team,
so she's out as well. And so is Ravi. So now
it's only me and Princess Peach left against
smarty-pants Smarties Charlotte and Jorja.

It's SO not fair, Diary. Why can't it be Zoe instead of Peach? We would be the dreamiest dream team in the history of dreamy dream teams.

I'm starting to get super stressed about the talent challenge in the final round. Peach and I should have worked out what we're going to do by now. But she never EVER talks to me when we're on the show. She's too busy checking her hair in the makeup mirror.

makeup
MIRROR

Or chatting to the boys from the other team. (Boys. Bleuchhh.)

Or telling all the TV
people in her fake
Teacher's Pet voice
how amazing and

wonderful and fantastically fabulous she is
at acting. And singing. And dancing.
And how it's ALWAYS been her DREAM
to be a Quiz ~~King~~ Princess on a TV show.

Double bleuchhh!

But guess what? Zoe reckons the REAL
reason Peach isn't talking to me is because
she is just a big JELLY BELLY BABY.
Because I got bonus points and she didn't.

Peach is **W-E-i-R-D**
spells weird.

C u tomorrow.
Ella xxx

Wednesday night, before dinner

Dearest Diary,

I am desperately distraught.

WARNING: TISSUE ALERT!

Today's round was the ACTiViTy CHALLENGE!

Charlotte and Jorja vs. Peach and me

We had half an hour to make a balloon tower, out of balloons. With one of our arms and legs tied together in the middle, like this:

Making a balloon tower when you only have one arm and one leg is really, really HARD, Diary.

Especially when the person you are making it with is your Ex-BFF who isn't talking to you anymore.

Which makes it EVEN HARDER when you have to blow up all the balloons yourself before you can even start. And tie knots in the end. With one hand. Like this:

Like THIS

And when half the knots come undone and then your balloons go WHIZZING all over the TV studio. Like this:

WHHHHEEEEEEE!

And when all the people in the audience and the man with the APPLAUSE sign and the TV directors and the camera people and the people running around with clipboards and microphones laugh their heads off. Like this:

It was SOOOOOO EMBARRASSING! Even Harry The Quiz King was laughing!

☹☹☹☹☹☹☹☹☹☹☹☹

This is what Charlotte and Jorja's balloon tower looked like at the end.

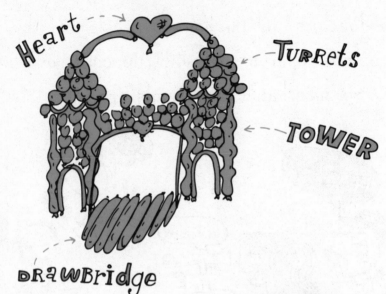

Heart

Turrets

Tower

Drawbridge

And this is what Peach's and *my* balloon tower looked like.

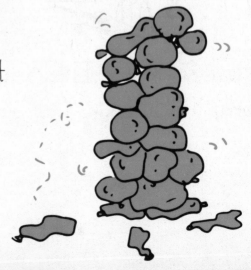

And then just when I was thinking that this was totally, definitely, completely the end, my life is over nothing can ever be this bad again, something even ~~worserer~~ worse happened.

Our scores for today's challenge flashed up on the screen behind us.

ROUND CHALLENGE!

The SMARTIES The QUIZZLY BEARS

(with **50 BONUS** points)

120 POINTS

60 POINTS

And even ~~worsererer~~ worse than that, The Smarties were given their bonus points for "displaying excellent teamwork."

Which is SO NOT FAIR because Jorja and Charlotte don't even like each other very much. They're always sniping and snitching at each other when the camera is turned off. And then they're all cutesy sweet and friendy pie when it's on again.

CAMERA OFF

CAMERA ON

They are just BIG FAKING FAKES.

Have to go now, Diary. Dad's calling me for dinner. Although I am so ~~mizzerible~~ ~~mizerable~~ sad I will probably never eat anything ever again.

Ella 😞

Wednesday night, after dinner

Dearest Diary,

As soon as dinner was over I called Zoe so we could have a quick EPM.

Here's what we said:

Me (worried): I am worried.
Zoe (worried-er): Same.
Me: We HAVE to do
really, really well and
get gazillions of
points in the final
talent challenge. If we
don't, The smarty-pants Smarties will win.
And everyone will call us Big Losers.
Zoe: I know.

Me: I need to get Peach to stop being a jealous jelly belly and start talking to me again.

Zoe (excited): Ooooooooo! I've just had one of my brilliant ideas!

Me: Ooooooooooo! What is it?

Zoe: Guess!

Me: We get Raf to turn Peach into a brainless zombie so she has to do everything we say?

Zoe: Nope. Guess again.

Me: We lock her in the hair-doing room and don't let her out (or have any hairdos) until she promises to start talking to me again?

Guess **again**.

Zoe: Nope. Guess again.

Me: We discover she has an identical cousin in Timbuktu and get her to go on the show instead?

Zoe: Nope. Guess again.

Me: I give up. What?

And then Zoe told me her brilliant plan.

Anyone with even a tiny brain knows that Peach LOVES being the star and the most important person in the room AT ALL TIMES.

So all we had
to do was
~~flatten~~ flatter
her with lots of
stuff about how
marvelously talented
and fantastically
fabulous she is at
singing and dancing
and doing backflips
and cartwheels.

The marvelously TALENTED AND FANtastically FABULOUS ★PEACH★ PARKER★

And how the talent challenge was her BIG
CHANCE to show everyone her amazing
skills. She might get asked to be on
ANOTHER TV show. Or even a movie!

But also how we needed to work out EXACTLY what we were going to do. And have a BIG practice of our act at school tomorrow before the final day of filming on Friday. So ~~she~~ we didn't look silly. Zow-ee!

Sweet dreams, Diary.
Ella

It's GOING to be AMAZING!

Thursday night, after school

Dearest Diary,

We did Zoe's Brilliant Plan on Peach and guess what?

It worked!

Peach and I put together an aMAZing act for our talent challenge. And we practiced it ALL recess and lunchtime. Ms. Weiss even let us do some extra practice during class time, instead of working on our explorers projects.

And then I had an EVEN MORE amazingly brilliant idea of my own!

We could sing the Quizzly Bears song I wrote as part of our act! And wear the fabulous costumes Zoe and I designed for our space-themed project last term!

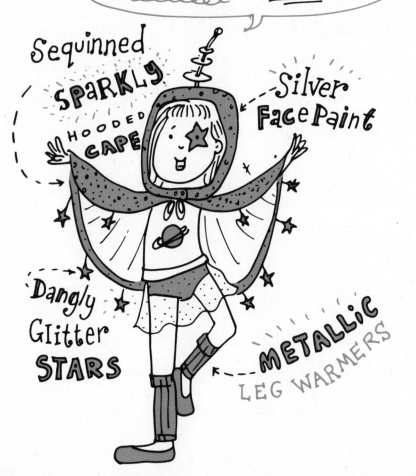

Everything is perfectly perfect. I can't wait until tomorrow!

Ella

xxx

Friday night, in bed

Dearest, darlingest Diary,

We did the talent challenge today. And it was aMAZing!

Here's what happened.

Smarty-pants Smarties Charlotte and Jorja
went first. And guess what they did?

You never, ever will, so I'll just tell you.

Plate spinning! On those teeny tiny bicycles
that only have one wheel! Dressed in sweet
little unicorn outfits!

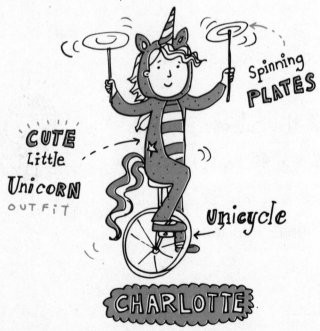

Spinning
PLATES

CUTE
Little
Unicorn
OUTFIT

Unicycle

CHARLOTTE

Everyone in the audience was cheering and clapping along to the music until . . .

Da da da . . . dummmm.

Charlotte rode her teeny tiny bike wheel over an old bit of cheese and tomato sandwich Jake accidentally dropped on the floor at lunchtime.

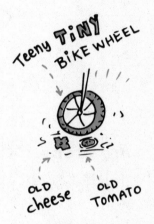

Teeny TiNY BiKE WHEEL

OLD cheese OLD TOMATO

And her bike wheel went WIBBLE WOBBLE WIBBLE WOBBLE and she lost her balance and all her plates came crashing down. Like this:

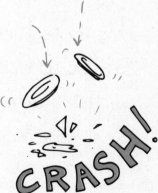

CRASH!

And then Jorja accidentally rode HER teeny tiny bike wheel over the crashed plates and she came crashing down as well. Like this:

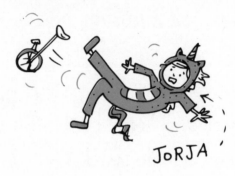

JORJA

And then Charlotte started crying. And so did Jorja. Really, really LOUDLY

And then the lady that does the lights turned them all off so you couldn't see anything anymore and we went to a break.

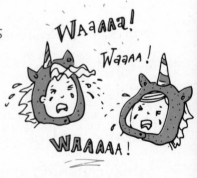

WAaaaa!

Waaaa!

WAAAAA!

Sasha and Jake came rushing up with brooms and dustpans and told us all to go and wait in the hair-doing room while they cleaned up all the mess.

And guess what happened in there?

Jorja told Charlotte she should have watched where she was going. And then she wouldn't have wibble wobbled her teeny tiny bike wheel all over the old bit of cheese and tomato sandwich.

Jorja

Charlotte

And then Charlotte told Jorja that SHE should have watched where SHE was going so she didn't wibble wobble HER teeny tiny bike wheel all over the crashed plates.

And then Jorja shouted,

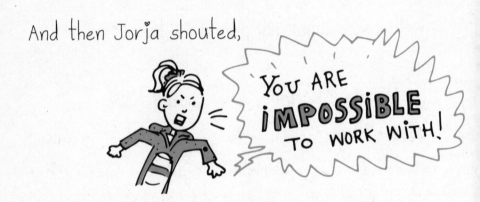

YOU ARE IMPOSSIBLE TO WORK WITH!

And Charlotte shouted back, "No, YOU are impossible to work with."

And then Jorja screeched, "That's it. I'm never doing anything with you EVER AGAIN!"

And Charlotte screeched back, "Neither am I!"

And then Jorja screamed, "Fine!"

And Charlotte screamed back, "Fine!"

And then they both stamped their feet, and turned their bottom lips inside out, like ~~Olivia~~ big babies. And stormed out of the room, like even BIGGER babies.

Peach and I gave each other a LOOK.
Like this:

Rolling our
EYES

Then Sasha came back in and said it was time for our act.

Peach gave me another look. Only this time it was a smile. PEACH! Smiling at ME!!!! And not even a smirking, sneery one!

She even said - 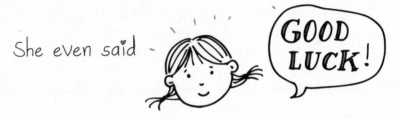 GOOD LUCK!

Peach NEVER says stuff like that. So I smiled and said "Good luck!" back.

Then we ran out of the hair-doing room and back over to the shiny counters wearing our sparkly space-themed outfits and did

some gymnastic
tricks right there
on top of them.
Super tricky ones,
like backflips and
cartwheels and
handstands.

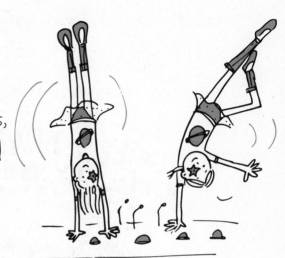

And we played a little tune on the buzzers
with our feet. Like this:

Then we jumped down again and sang my
Quizzly Bears song together. We even linked
arms while we were singing it! Like this:

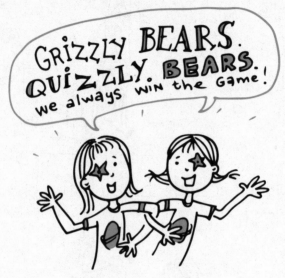

And guess what?

We DID win the round!

Zow-ee!

Then Charlotte and Jorja came back onto
the set. Hehehe. They didn't look very happy.

We all stood there while the Quiz-zam!
theme song played, waiting for the judges
to add up all the points from the four
different rounds into one big total score.

And then the buzzers bwarped again.

And our total scores flashed up onto the screen behind us.

The QUIZZLY BEARS	The SMARTIES
410	390
POINTS	POINTS

And then glittery golden glitter fell down out of the roof part all over Peach and me.

We'd won! By twenty points!

YESSSSSS!

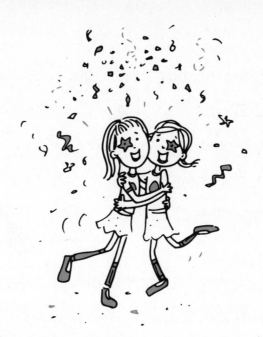

Peach and I did a little squeal. And then we gave each other a big hug!

And a girl wearing a sparkly dress and big hair came out and gave us a gigantic box with all our prizes in it!

We won a new computer for our school!

And everyone on our team got free passes to the water park! And a Quizzy watch! Jake and Sasha gave Zoe a Quizzy watch too, for being such an excellent official emergency player.

watch

(They gave some "consolation" prizes to The Smarties team too, but they weren't as exciting as ours. Just stuff like Quizzy toys and the Quiz-Zam! board game. I think Zoe's and my Smarty-Pants board game is MUCH better.)

Board GAME

Peach and I worked together REALLY well today.

I wonder if this means that we're going to be friends again?

Nighty night.
Ella xoxo

PS (one month later)

Our show was finally on TV! Which is just as well because being STS (Sworn to Secrecy) has been REALLY hard, Diary. I've been BURSTING to tell everyone we'd won!

Ms. Weiss organized a special viewing party for our class after school.

And we had drinks and snacks and a special cake with 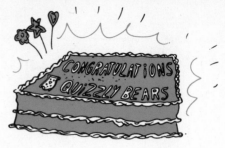 writing on the top! It was excellent. And amazing. And fantastically fabulous.

PPS (five minutes later)

And you know how I wrote that stuff about maybe being BFFs again with Peach?

That was BEFORE she told everyone that doing the handstands and the buzzer dance and singing the Quizzly Bears song in sparkly space-themed outfits for the talent

challenge had all been HER idea. And that's why we'd won.

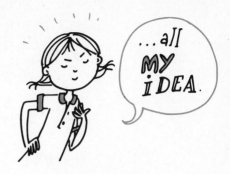

Ha! That is SO not true. Especially as it was MY bonus points that made all the difference to the total scores at the end! So guess what?

We're not.

Just as well I've got two OTHER really excellent BFFs. ☺

Read more brilliant diaries!